BP PORTRAIT AWARD 2005

BP PORTRAIT AWARD 2005

National Portrait Gallery

Published in Great Britain by
National Portrait Gallery Publications,
National Portrait Gallery,
St Martin's Place, London WC2H 0HE

Published to accompany
the BP Portrait Award 2005,
held at the National Portrait Gallery, London,
from 15 June to 25 September 2005,
Sunderland Museum & Winter Gardens,
from 6 October to 27 November 2005,
and the Scottish National Portrait Gallery, Edinburgh,
from 17 December 2005 to 12 March 2006.

For a complete catalogue of current
publications please write to the address above,
or visit our website at www.npg.org.uk/publications

ISBN 1 85514 365 8

A catalogue record for this book
is available from the British Library.

Publishing Manager: Celia Joicey
Editor: Caroline Brooke Johnson
Design: Anne Sørensen
Production Manager: Ruth Müller-Wirth
Photography: Prudence Cuming
Travel Award photography: Electric *Film* Company
Printed and bound by Westerham Press, England

Cover: *Portrait of Chantal Menard* by Sean Cheetham

PREFACE 6
Sandy Nairne

FOREWORD 7
Lord Browne

PRIVACY AND INTRUSION 8
Philip Hensher

BP PORTRAIT AWARD 2005 15

FIRST PRIZE 17
Dean Marsh

SECOND PRIZE 18
Saul Robertson

THIRD PRIZE 19
Gregory Cumins

FOURTH PRIZE 20
Conor Walton

SELECTED PORTRAITS 21

BP TRAVEL AWARD 71

PORTRAITS IN IRAN 73
Darvish Fakhr

ACKNOWLEDGEMENTS 79

INDEX 80

PREFACE

Another record entry – 1,081 submitted paintings – has impressed the judges for this year's BP Portrait Award. Once again the works include a mix of images both delightful and bewildering. The portraits are judged anonymously, with no idea of who the artist might be, and painting and pose are not contained within any set of rules about how the subject should appear. Large, standard or small works are examined simply one after the other. Only after the two days of judging is complete do we know anything of the artist: their age, gender, location or nationality.

The Portrait Award starts with the assumption that a portrait is much more than a face, that it will attempt to communicate something of the whole person. The rules ask that the sitter has sat for the artist – that these are not fantasy portraits or dream images. So here is a closely rendered study of a young woman seated in the studio, there an older man looking worried, here a large lady with glasses and a cat, here a family in the living room – playing video games – and there a large baby with chicken pox. Some portraits have the virtue of their immediacy, of conveying likeness through intense concentration and skilled brushwork; others are expressive renderings, setting out a face and figure as if depicting a landscape. A number are obviously drawn directly with the paint layered on top, others use photographs in the development of the image, while many exploit the particularities of acrylic or oil paint. Whatever technique is employed, and however private in origin, the painters all have a determination to communicate and a desire for their portraits to be seen in the Gallery by the public.

I very much hope that you enjoy these selected works, as much as we enjoyed choosing them.

SANDY NAIRNE
Director, National Portrait Gallery

FOREWORD

BP recognises the role that arts and culture play in the economic and social fabric of the country. We maintain a focus on excellence and seek mutual advantage through projects that help create stable, open and thriving communities. We support some of Britain's most outstanding cultural institutions, including the National Portrait Gallery.

Over the past fifteen years, the BP Portrait Award has consistently demonstrated the artistic potential of figurative art. The growth in the number of entrants and visitors to the exhibition, from across the United Kingdom and abroad, is encouraging evidence of the role of the Award in developing artistic talent and the understanding and appreciation of portraiture.

BP is delighted to be associated with the Award and to continue our partnership with the National Portrait Gallery. The skill and commitment of the Gallery's staff have turned what began as a small and experimental project into a sustained, internationally recognised success. Our thanks are due to them and, of course, to the talented artists who have captured human character on a two-dimensional canvas.

LORD BROWNE OF MADINGLEY
Group Chief Executive, BP

In their book on Raphael, Roger Jones and Nicholas Penny end their chapter on his portraits with a shrug, and an apology: 'The more we study Raphael's portraits, the more we must acknowledge that they were not painted for us.' It's a tantalising thought: a genre of painting whose audience does not include 'us', and may not include a 'public' at all. Most classical genres of painting do imply a public. Renaissance mythological or religious painting teaches a moral; much English landscape painting turns out to be boasting about the extent of a nobleman's estates. Dutch flower paintings are often fantasies of conspicuous expenditure; even the pornographic images of Jean Honoré Fragonard or Félicien Rops rest on the idea of a select audience of connoisseurs.

There is very little painting that convincingly attempts the appearance of privacy. Much of it is in the form of portraiture. Portraiture need not be private; indeed, from the earliest times, most of it had a public aspect, promoting images of rulers and celebrities. Oddly, in most periods, the form of portraiture least likely to be thought of as private was the self-portrait. Often – as in Rembrandt's self-portraits – they were executed partly to draw in prospective clients. In an age before mechanical reproduction, the self-portrait was quite simply the easiest way to demonstrate the artist's skill in drawing a likeness. They look to us like utterly private self-communings; to Rembrandt's contemporaries, they had something of the nature of a billboard.

Some portraits really do exploit the idea of privacy. We sense that we are intruding on the deeply private communion between artist and sitter, or, perhaps, where a portrait was intended as a gift for some unseen, unknown third person. They knew what the portrait meant; centuries later, the rest of us intrude rudely, guessing. Raphael's *Bindo Altoviti* (c.1515) was very much not painted for us. His direct, soft gaze has a daunting intimacy, but it is meant, surely, only for the eyes of a mistress. The almost shockingly sultry eroticism needs no explanation; despite the fact that Altoviti was a very wealthy public man – he was a banker – there are no

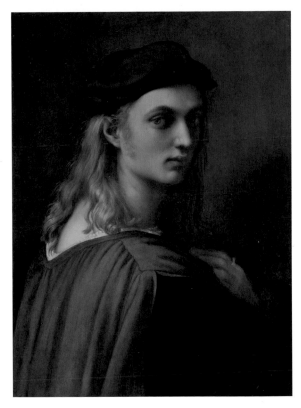

BINDO ALTOVITI
Raphael, c.1515
Oil on panel
597 x 428mm
(23½ x 17¼")
National Gallery of Art,
Washington DC

trappings in the painting from which to draw a moral, no jewels or emblems to indicate his power. It is simply him, his extraordinary, almost tawdry beauty, gazing at us: and we should not be here.

That, at least, is an immediate reaction. But it under-estimates the cunning of the artist. Of course, we are meant to think all this. We are meant to feel like intruders on a private relationship. The quality of intimacy, and of unreadable mystery is present in many portraits which, in reality, were publicly exhibited from the start. The real sensation here is not intimacy, which genuinely excludes us, but the thrill of the illicit, which includes the observer even while seeming to forbid him or her. The power of the illicit is most powerful, perhaps, when

anonymity has swallowed the subject, the painter or both. A familiar painter's depiction of a famous subject, the works that form most of the National Portrait Gallery's collection, may seem to address us from a position of double authority. Many of the works in the BP Portrait Award competition have a more mysterious effect; if the artist is not familiar to us, if we don't know the sitter, that tantalising and even erotic effect of illicit intrusion starts to tease us.

How can literature rival this wonderful effect? Literature is too complete, knows too much; those are its virtues. We slip into its world, but almost invariably, we are observers; we don't feel, as we so often do with portraiture, that in some way we are intruding, and odder than that, being observed. We don't often feel that literature has left a space for us quite like the space a sitter's gaze constructs, almost like a karaoke track, waiting for an anonymous passing observer to supply the missing voice.

When I was younger, I produced some academic work on English eighteenth-century painting, and, loving the period and its gestures, discovered that you didn't have to be rich to possess something of it. On the whole, if a dealer can't discover the painter of a portrait, or the identity of the sitter, and (oddly enough) if it is a portrait of a man, it won't be that expensive even if it is a very handsome painting. Those factors appealed to me, and I have a couple of portraits at home that preserve a completely mysterious, quizzical expression. Who was this for? Who is looking back at me? Why was he worth painting? There is magic in the unanswered gaze, and sometimes, with these things in my house, I feel like a kidnapper.

One of the principal mechanisms of intimacy in a portrait is the direct gaze. The gaze that looks directly outward, like that of Raphael's *Bindo Altoviti*, and engages our own has a complex force. In a portrait of a single figure, it can imply a particular one-man or one-woman audience, returning the tender regard. In the case, say, of that great portrait by Allan Ramsay of the painter's second wife (1754–5), her startled gaze

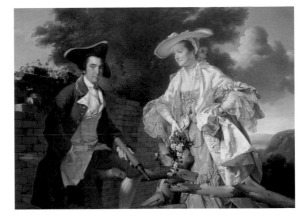

PETER PEREZ
BURDETT AND HIS
FIRST WIFE HANNAH
Joseph Wright
of Derby, 1765
Oil on canvas
900 x 1200mm
(35¹/₂ x 47¹/₄")
National Gallery,
Prague

clearly implies the painter's tender, observing one; a closed, private exchange between the two of them. In paintings of more than one sitter, it is always worth considering the figures whose gaze engages our own.

This ambiguous privacy in portraiture, the way it both admits and excludes a public audience, is one unique to the visual arts. A writer could not achieve it. The nearest thing would be a sequence of private letters. But that is not an exact comparison, because letters are genuinely private; there is nothing more insufferable than a seemingly private correspondence that evidently has an eventual public in mind. Portraiture is capable of containing the private exchanges and secret significances available only to two or three people, and the ultimate response, even the highly sincere one of embarrassment, of a large, unknowable public.

Joseph Wright of Derby's *Peter Perez Burdett and his First Wife Hannah* (1765) has always haunted me. Like the *Bindo Altoviti* portrait, it is immediately frank and ultimately unreadable. Perez Burdett was a cartographer, and he is depicted, honestly and conventionally, with the correct professional properties. But the relationship with his wife is baffling. Their moods seem utterly incompatible: his cheerful undone slovenliness, the lavish expenditure of his ageing wife's costume; his direct and knowing gaze, her dull, even regretful one. No wonder

there is a barrier between them; but the observer is paralysed by the mystery of so grand and exuberant a portrait, devoted to what seems a sad and even cruel relationship. It is an embarrassing painting to look at, telling us too much. The crucial image is the telescope in Perez Burdett's hand: you know that his gaze is customarily directed, as it is here, away from his wife, and usually very far away.

There is an inexact parallel to be drawn between such knowing portraits and the literary art of dramatic irony. William Hogarth, the most literary of painters, does use literary dramatic irony, in the sense that some private knowledge is shared between him and us, but concealed from his sitters. In *The Graham Children* (1742) in the National Gallery, most of the emblems – the singing bird, the toy organ, the pet cat, the cherries – might be emblems of innocence, of childhood pleasures. But we can see, as the children don't, that together they make up a horrifying image of cruelty, torment and unfulfilled selfish desire. The bird is not singing for joy but in terror. Such a painting, firmly literary in its rhetoric, is essentially a public painting, obtained by a degree of deception. Wright's double portrait, on the other hand, rests on a frank communion between painter and sitters.

Frequently, a painter gives this sense of intimacy through an unexplained gesture or emblem; sometimes, through licensing behaviour that would not be tolerated in the real world and inverting the social hierarchy. In one of Sir Joshua Reynolds's grandest portraits, *The Family of the Duke of Marlborough* (1777–8), the most important figures are solid and remote; the life of the picture rests in the smallest children, play-acting in the foreground and who alone engage our gaze. When access is given not just to the grand, public figures in a great household, but to the children or servants, public portraiture is turned into a private communion. A famous example is a Mogul double portrait from the 1620s, *Sheikh Hosein Jami and his Attendant*. Though the name of the servant has been lost, within the miniature he possesses a marvellous equality with his master. Their

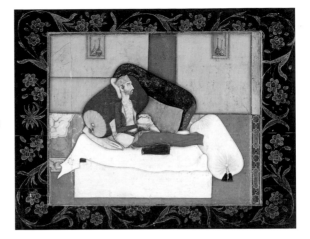

NAYAT KHAN,
THE DYING COURTIER
Unsigned, 1618
Gouache on paper
186 x 112mm
(7¼ x 4⅜")
Bodleian Library,
Oxford

tasks are different: the noble Sufi mystic in spiritual meditation, the servant preparing *paan*; both are proper portraits, the servant not reduced to a type. We are admitted to the most private realm of a household here.

Miniaturists, like other great portraitists, can occupy intimate spaces. In another celebrated miniature, the dying courtier Inayat Khan (1618) is depicted horribly wasted by opium and drink. The painter willingly shows us, to the point of impropriety, what we should not witness. There is no warning here, and no consolation for us: only a terrible sense of shame. The sheikh's blindness is unsparingly depicted. As it happens, we know that this portrait was ordered to be taken by the emperor Jahangir, who was interested in the phenomenon, as he was interested in other oddities of natural phenomena – at least, so his memoirs suggest. The peculiar privacy of the image arises from a triple aspect: for Jahangir, it represented a fine curiosity for his private cabinet; for this miniaturist, the intimate respect his art paid to individuals; for Inayat Khan, only the frightful final catastrophe of his body. None of these requires a public, and we feel like intruders, three times over.

These effects of intrusion and privacy are achieved without the most characteristic and troubling device of Western art, the sitter's gaze. The Western gaze,

particularly the gaze that looks directly outward at us, engaging our own gaze, fascinates me because it has, really, no literary parallel at all. As writers, we can make people speak in the first person, telling their own stories; we can even, more exotically, make our depicted people address another, telling a story largely in the second person, as Italo Calvino does at the beginning of *Se una notte d'inverno un viaggiatore* (1979), or Jay McInerney does in *Bright Lights, Big City* (1985). Those are similar effects, but not quite like the recurrent effect of the direct gaze in Western portraiture.

When we look, now, at a portrait which uses the direct gaze, such as the Raphael *Bindo Altoviti* or Allan Ramsay's portrait of his second wife, we feel that the painting has created a hero, or heroine; we have someone saying 'This is who I am' with his or her direct and unreadable expression. But the painting also seems to begin a dialogue: the sitter is looking outwards, at someone else. We often feel that there was, originally, a very specific object of this gaze: perhaps the painter taking the likeness, perhaps someone to whom the painting would be given. But we feel, too, that the painting is saying 'you' to a vast crowd of anonymous, shadowy people: people like us, evanescent, and slipping for a moment into the frank splendour of an unseeing inspection.

PHILIP HENSHER

BP PORTRAIT AWARD 2005

The Portrait Award, now in its twenty-sixth year at the National Portrait Gallery and fifteenth year of sponsorship by BP, is an annual event.

It is aimed at encouraging young artists from around the world, aged between eighteen and forty, to focus upon and develop portraiture within their work. Many of the exhibiting artists have gained commissions as a result of the interest aroused by the Portrait Award.

THE JUDGES

Chair: Sandy Nairne, Director, National Portrait Gallery

Maggi Hambling, Artist

Juliet Horsley, Curator, Sunderland Museum & Winter Gardens

Brian Sewell, Art Critic, the *Evening Standard*

Des Violaris, Director, UK Arts & Culture, BP

THE PRIZE WINNERS

First Prize
Dean Marsh who receives £25,000, plus a commission worth £4,000 to paint a well-known person

Second Prize
Saul Robertson who receives £6,000

Third Prize
Gregory Cumins who receives £4,000

Fourth Prize
Conor Walton who receives £2,000

PRIZE-WINNING PORTRAITS

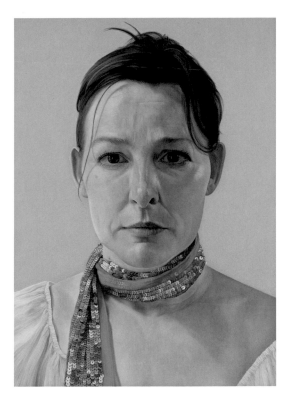

GIULIETTA COATES
Dean Marsh
Oil on board, 731 x 575mm (28³/₄ x 22⁵/₈")

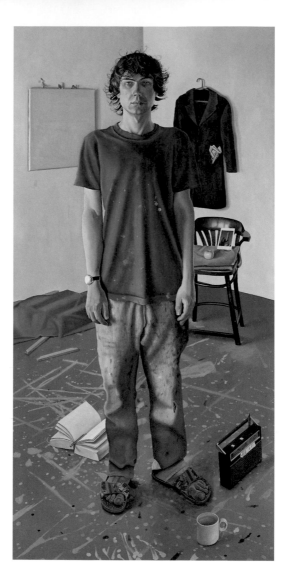

THE UNIVERSE
Saul Robertson
Oil on linen, 1511 x 770mm (59^1/$_2$ x 30^1/$_4$")

18

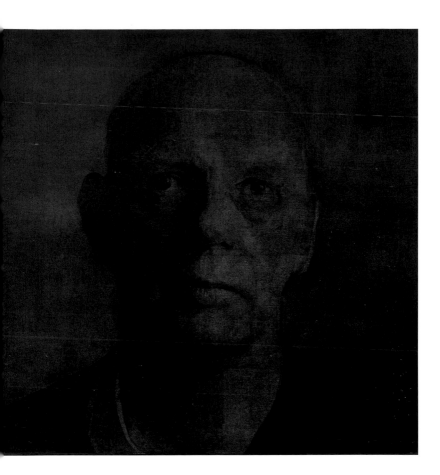

RICHARD DEACON
Gregory Cumins
Mixed media, 1500 x 1510mm (59^1/$_8$ x 59^1/$_2$")

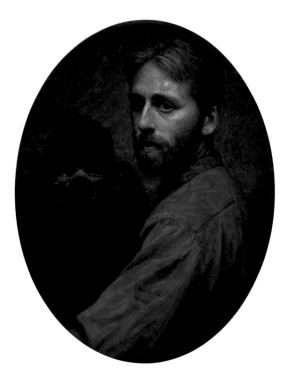

MONKEY PAINTING
Conor Walton
Oil on panel, 775 x 620mm (30$^{1}/_{2}$ x 24$^{3}/_{8}$")

SELECTED PORTRAITS

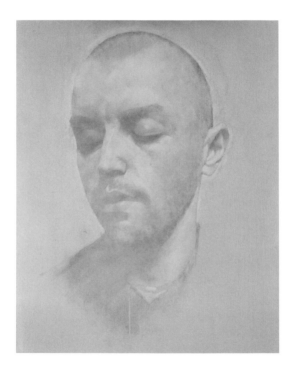

BENNI
Jackie Anderson
Oil on board, 370 x 292mm (14$^1/_2$ x 11$^1/_8$")

22

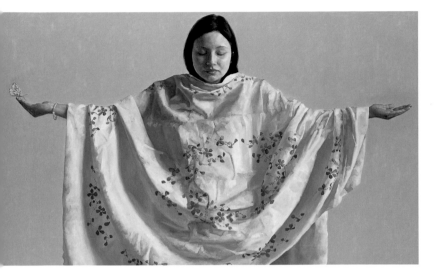

FALLING
Jennifer Anderson
Oil on canvas, 1030 x 1680mm (40¹/₂ x 66¹/₈")

23

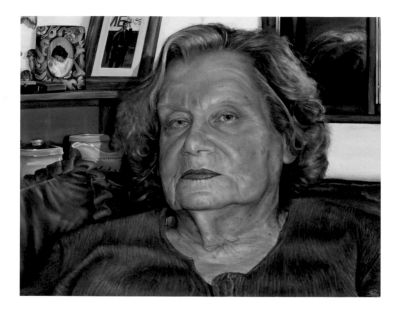

WAITING FOR MARGARET
Paul Birdsall
Oil on canvas, 715 x 922mm (28⅛ x 36¼")

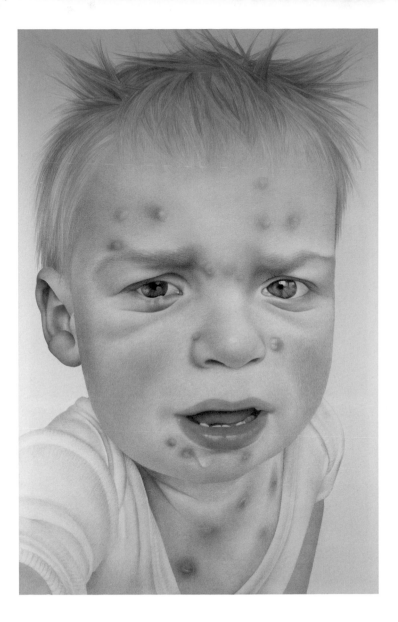

CHICKEN POX
Annemarie Busschers
Acrylic on canvas, 2500 x 1600mm (98½ x 63")

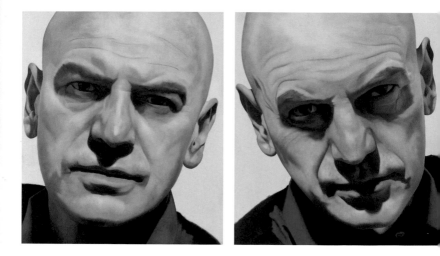

DOMANDA E RISPOSTA
Davide Castronova
Oil on board, 326 x 280mm (12^{7}/$_{8}$ x 11") x 2

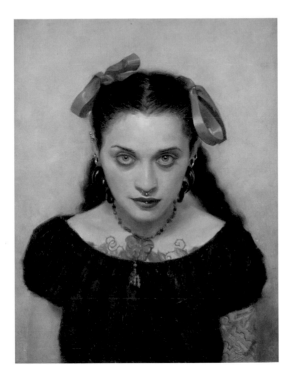

PORTRAIT OF CHANTAL MENARD
Sean Cheetham
Oil on panel, 354 x 304mm (14 x 12")

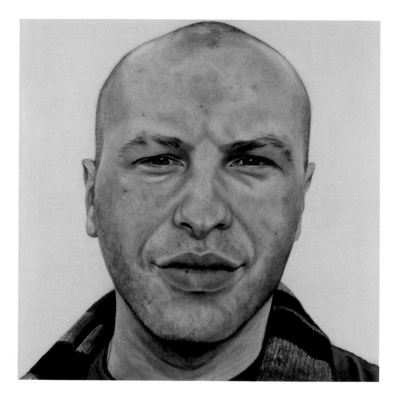

PAUL
Sylvie Clarke
Oil on canvas, 920 x 920mm (36$\frac{1}{4}$ x 36$\frac{1}{4}$")

28

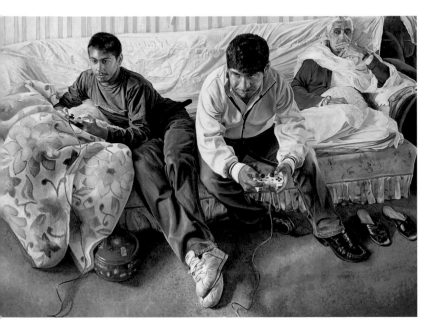

GRAN TURISMO
Megan Davies
Oil on canvas, 1255 x 1718mm (48³/₈ x 67⁵/₈")

PERSON 2004/5
Roy Eastland
Acrylic on board, 280 x 255mm (11 x 10")

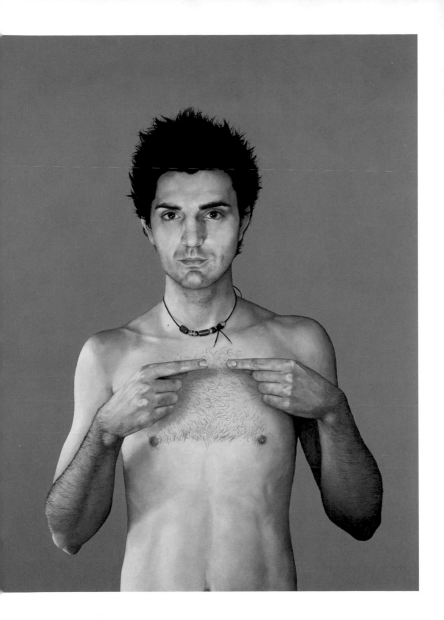

SEBASTIEN
Joel Ely
Oil on canvas, 1220 x 915mm (48 x 36")

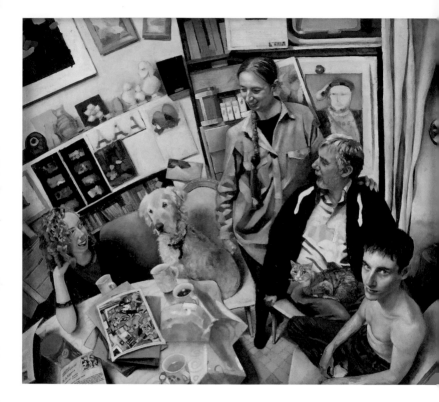

PORTRAIT OF SALLY ESDAILE & HER FAMILY OR TEA-TIME
Eneko Fraile-Ugalde
Oil on canvas, 800 x 890mm (31½ x 35")

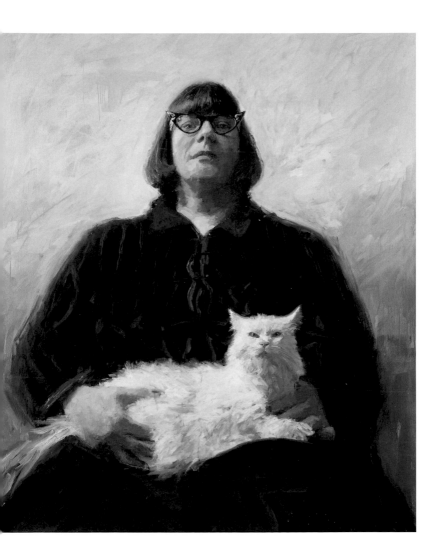

ANNA AND KIKI
James Hart Dyke
Oil on canvas, 1800 x 1540mm (70^{7}/$_{8}$ x 60^{5}/$_{8}$")

33

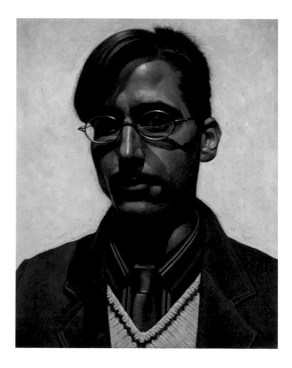

TIBI TIBI
Daniel Hughes
Oil on board, 510 x 410mm (20$^{1}/_{8}$ x 16$^{1}/_{8}$")

34

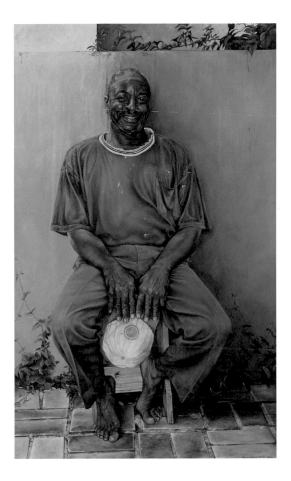

TELL ME
Helena Hugo
Oil on board, 970 x 660mm (38¹/₄ x 26")

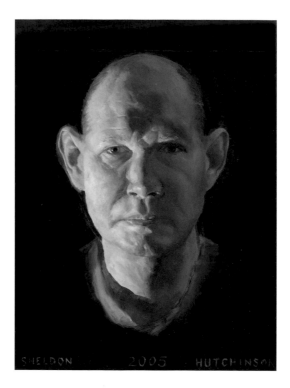

FIVE TO MIDNIGHT
Sheldon Hutchinson
Oil on board, 599 x 485mm (23$^1/_2$ x 19$^1/_8$")

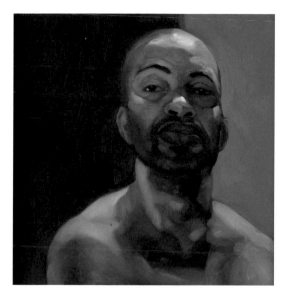

THIS IS ME WHEN I'M PAINTING (SELF-PORTRAIT)
Shaun James Nielsen
Oil on board, 570 x 570mm (22$^1/_2$ x 22$^1/_2$")

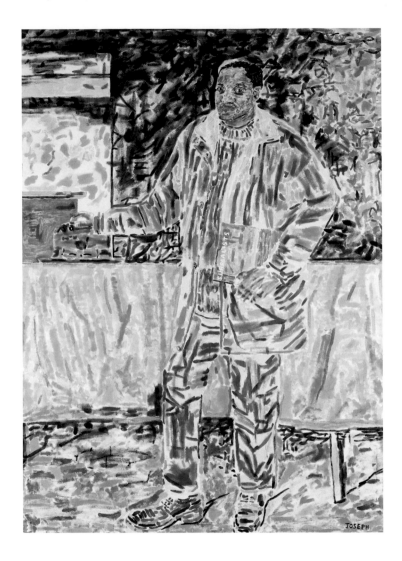

SIR DUNCAN JOSEPH
Duncan Joseph
Oil on canvas, 1940 x 1445mm (76³/₈ x 56⁷/₈")

MY BROTHER (PAUL)
Brendan Kelly
Acrylic on canvas, 1780 x 2180mm (70^{1}/$_{8}$ x 85^{7}/$_{8}$")

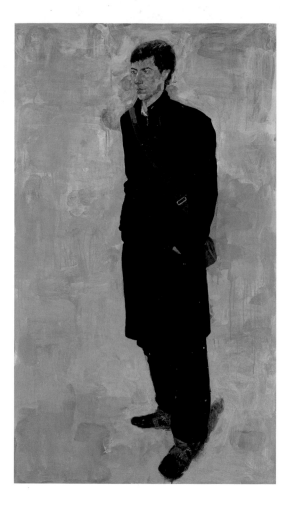

MORGAN
Jack Kettlewell
Acrylic on canvas, 1543 x 886mm (60³/₄ x 34⁷/₈")

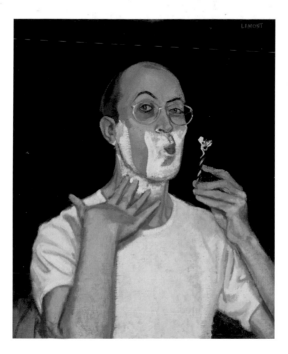

SELF-PORTRAIT, SHAVING 2 (RETURN OF THE MACH)
Ian Lamont
Oil on canvas on board, 730 x 630mm (28³/₄ x 24³/₄")

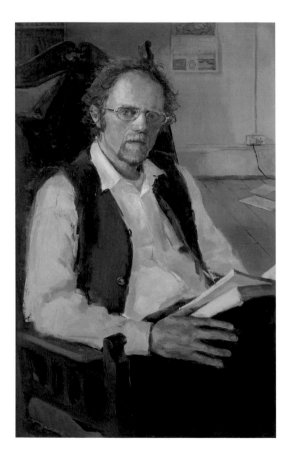

PORTRAIT OF KEVIN KIELY – WRITER
Maeve McCarthy
Oil on panel, 1210 x 845mm (47⅝ x 33¼")

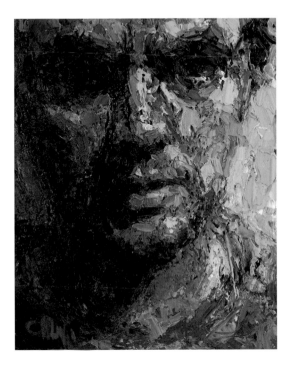

SELF-PORTRAIT
Cian McLoughlin
Oil on canvas, 690 x 580mm (27¹/₈ x 22⁷/₈")

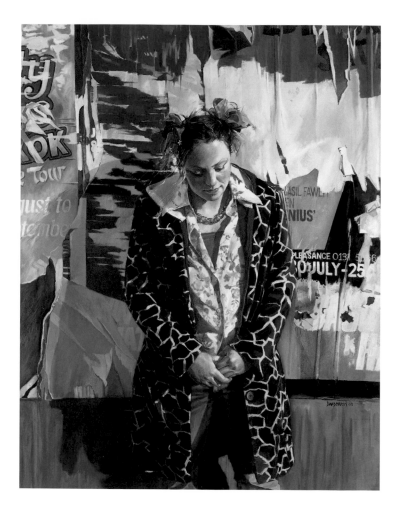

END OF THE FESTIVAL
David Martin
Oil on canvas, 1290 x 1040mm (50³/₄ x 41")

BEKY STODDART (MURAL PAINTER)
Nicholas Middleton
Oil on canvas, 910 x 910mm (35$^7/_8$ x 35$^7/_8$")

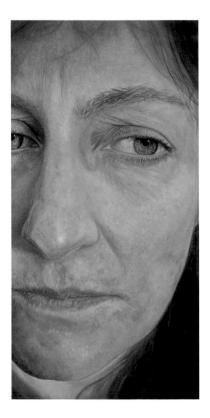

CLAIRE
Graham Milton
Oil on canvas, 1003 x 503mm (39^1/$_2$ x 19^3/$_4$")

46

SELF-PORTRAIT
Daniel Munday
Oil on canvas, 380 x 370mm (15 x 14¹/₂")

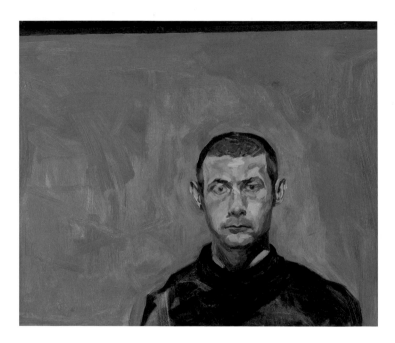

A QUIET PLACE
John Murphy-Woolford
Oil on board, 558 x 680mm (22 x 26³/₄")

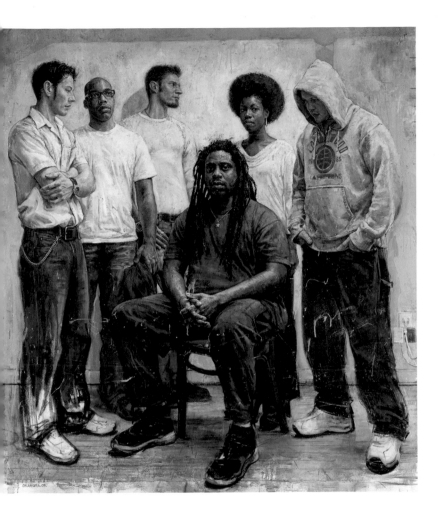

LA FAMILIA
Tim Okamura
Oil on canvas, 2040 x 1840mm (80¼ x 72½")

49

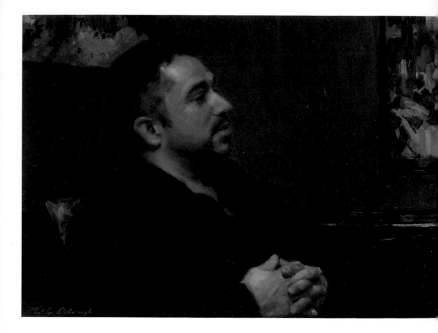

JAVIER
Paul Oxborough
Oil on linen, 790 x 990mm (31¹/₈ x 39")

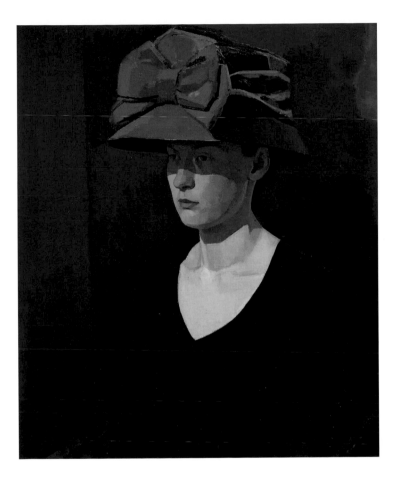

L AS MISS PALMER AFTER REYNOLDS
Andy Pankhurst
Oil on canvas, 920 x 790mm (36¼ x 31⅛")

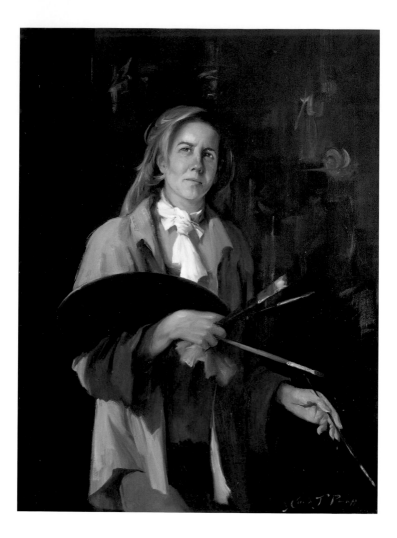

SELF-PORTRAIT IN FRONT OF 'RED DAWN 2005'
Nicky Philipps
Oil on canvas, 1250 x 994mm (49$^{1}/_{4}$ x 39$^{1}/_{8}$")

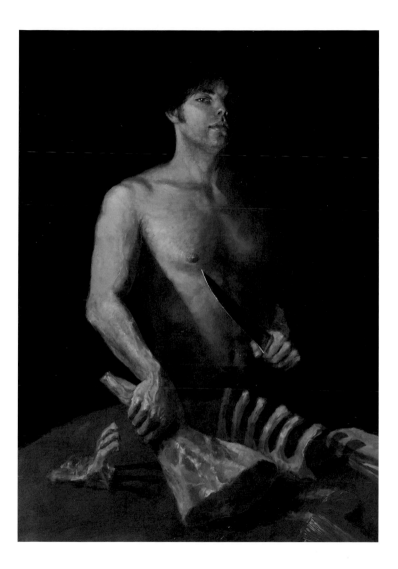

(SELF-PORTRAIT) WITH KNIFE AND MEAT
Alex Rennie
Oil on canvas, 1220 x 870mm (48 x 34¹/₄")

THE OSWESTRY CONNECTION
Stephen Earl Rogers
Oil on board, 710 x 850mm (28 x 33$\frac{1}{2}$")

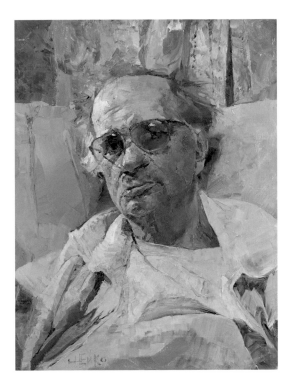

AILING NOVELIST
Konstantin Sheiko
Oil on canvas, 610 x 455mm (24 x 17⁷/₈")

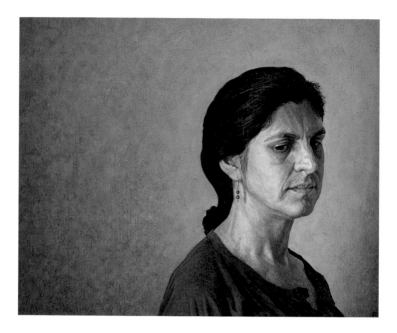

MARIA
Paul Smith
Oil on canvas, 500 x 580mm (19³/₄ x 22⁷/₈")

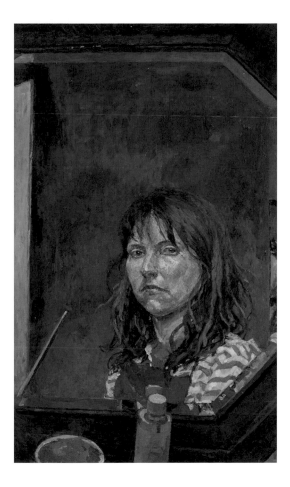

OLDER
Charlotte Steel
Oil on board, 780 x 510mm (30³/₄ x 20¹/₈")

57

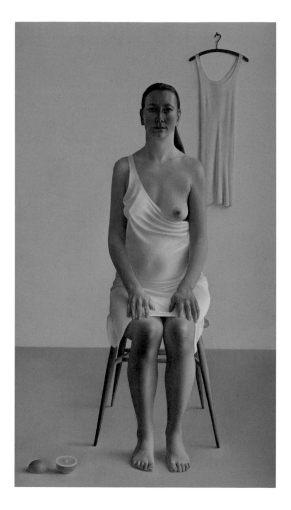

SELF-PORTRAIT
Bonnie Thompson
Oil on board, 440 x 330mm (17³/₈ x 13")

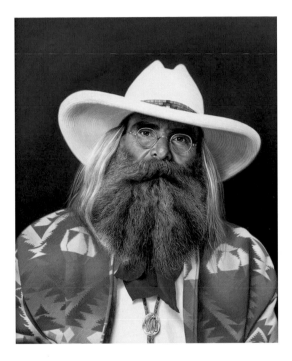

DANIEL
Andrew Tift
Acrylic on canvas, 465 x 395mm (18³/₈ x 15¹/₂")

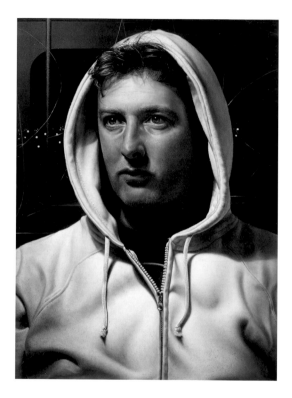

ARRIVAL
Stefan Towler
Oil on board, 529 x 415mm (20⁷/₈ x 16³/₈")

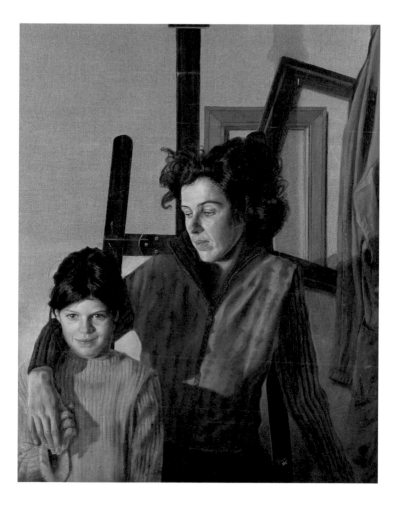

WIFE AND DAUGHTER
Thierry Louis Tremas
Oil on canvas, 925 x 730mm (36³/₈ x 28³/₄")

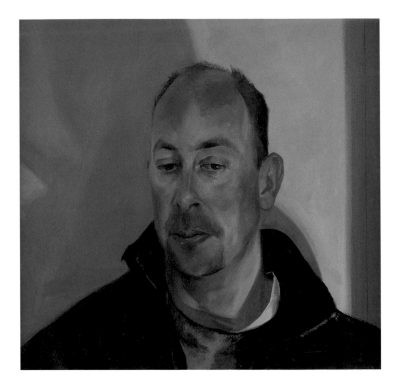

ANGUS
Jason Walker
Oil on board, 538 x 570mm (21^1/$_8$ x 22^1/$_2$")

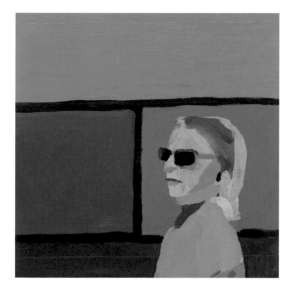

ORANGE ANGEL
David Webb
Acrylic and oil on canvas, 290 x 295mm (11³/₈ x 11¹/₂")

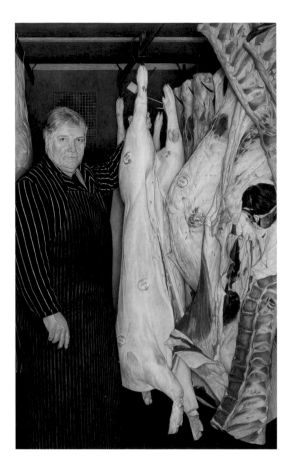

DAVID ARNOLD
Emma Wesley
Acrylic on board, 1580 x 1010mm (62¹/₄ x 39³/₄")

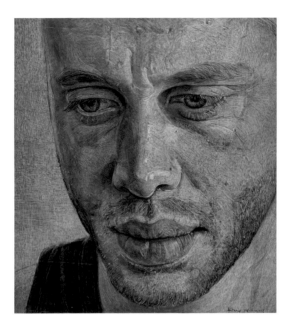

ED
Antony Williams
Egg tempera on panel, 548 x 500mm (21$\frac{1}{2}$ x 19$\frac{3}{4}$")

65

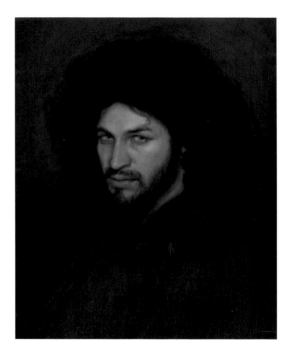

UNTITLED
Hugo Wilson
Oil on canvas, 778 x 680mm (30⁵/₈ x 26³/₄")

THE CRAFTSMAN
Daniel Wray
Oil on board, 650 x 1170mm (25$^1/_2$ x 46$^1/_8$")

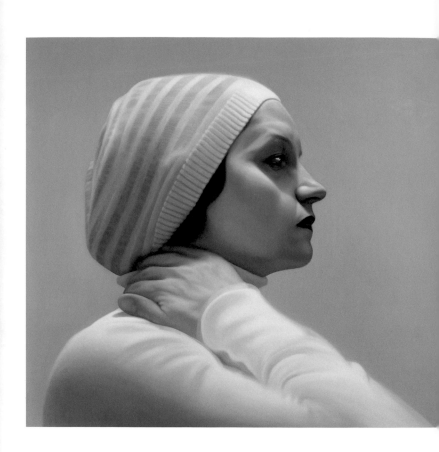

K.R.
Craig Wylie
Oil on linen, 1280 x 1680mm (50³/₈ x 66¹/₈")

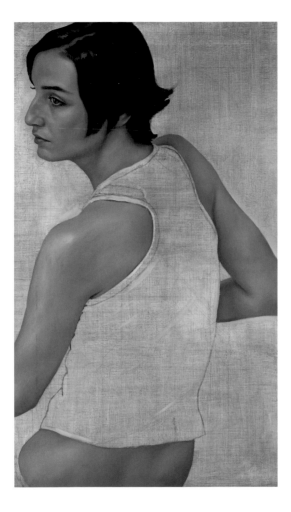

ERIN
Jonathan Yeo
Oil on canvas, 1100 x 720mm (43³/₈ x 28³/₈")

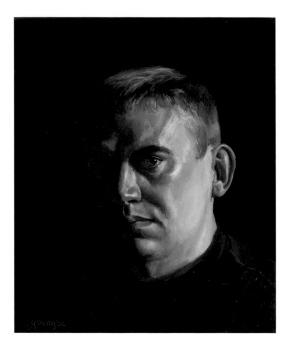

SELF-PORTRAIT
Gavin Young
Oil on board, 385 x 360mm (15^1/$_8$ x 14^1/$_8$")

BP TRAVEL AWARD

BP TRAVEL AWARD INFORMATION

Each year exhibitors are invited to submit a proposal for
the BP Travel Award. The aim of the Award is to give
an artist the opportunity to experience working in a
different environment, in Britain or abroad, on a project
related to portraiture. The artist's work is then shown as
part of the following year's BP Portrait Award exhibition
and tour.

THE JUDGES 2004 AND 2005

Sarah Howgate, Contemporary Curator,
National Portrait Gallery

Liz Rideal, Art Education Officer,
National Portrait Gallery

Des Violaris, Director, UK Arts & Culture, BP

THE PRIZE WINNER 2004

Darvish Fakhr who received £4,000 for his proposal to
paint portraits in the old Persian bazaar, Iran.

PORTRAITS IN IRAN

My proposal to paint Iran was a personal one. Since my youth in America, I have felt the antagonism that goes with being half-Iranian in the West. It's a hostility I couldn't understand, as all the Iranians I've ever known have been generous and compassionate. I felt obliged to present Iranians as they are, by going to the country and doing what I do best: painting the people.

I arrived in Iran in October 2004 and divided my time between Tehran and Isfahan. Although I found plenty of subjects in the old bazaar and enjoyed asking people to sit for me, I wanted to show more of this complex country than just the stereotypical imagery of the bazaar. The old world is one aspect of Iran, but what interested me more was how the country has adapted to incorporate modern-day life and Western influences.

Iranians are not used to having their portraits painted. It's not been part of their tradition as the portrayal of figures has been considered sacrilegious. Although those restrictions are not enforced today, the only professional portraiture that is prevalent is wedding photography, which is so airbrushed and contrived that often the sitters are unrecognisable. Therefore, as a realist portrait painter in Iran, my sitters were often shocked and sometimes offended by my honesty.

PAINTING IN THE BAZAAR

Since I didn't have any of my studio equipment I ended up painting the larger canvases by bending over a canvas rolled out in front of me. Although this proved difficult in terms of viewing the overall drawing, it gave me the freedom of not being too fussy about details.

Painting in the bazaars proved challenging in a number of ways. First of all space is a commodity there, and if you are not selling or buying, you are basically in the way. So I had to be selective as to where I could set up so as not to be a nuisance. The other challenging aspect was working with a crowd of onlookers. When I stepped back to look at my picture, they would all step back with me as though we were choreographing a new dance step.

UNCLE MOHSEN
AND MANISHE
(UNFINISHED)
Darvish Fakhr
Oil on canvas
1270 x 1702mm
(50 x 67")

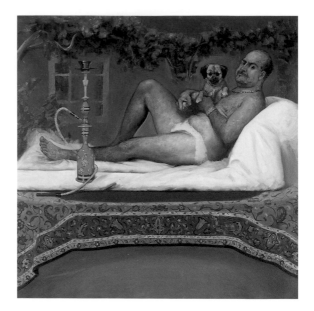

UNCLE MOHSEN AND MANISHE

Uncle Mohsen was born and raised in Isfahan, Iran. He wanted to be an artist but was discouraged from an early age since art was not considered a noble pursuit. He roamed around Europe for a while and lived in Los Angeles for twenty years where he restored paintings and Persian carpets. Now he is back in Isfahan renovating the house where he grew up and living alone with his dog, Manishe, who he refers to as the Mrs. He walks around all day in his underwear watering plants in his garden and at night he sleeps outside when the weather is warm enough.

In the mornings I would take his dog for walks by the river where I would get strange looks and comments. Dogs are used for herding sheep in Iran, not for sitting on laps. When Mohsen wasn't showing me the back alleys of the bazaar, he would sit for me with Manishe. He and Manishe proved to be great friends and excellent sitters. After seeing his portrait, my uncle Mohsen went on to lose fifteen pounds.

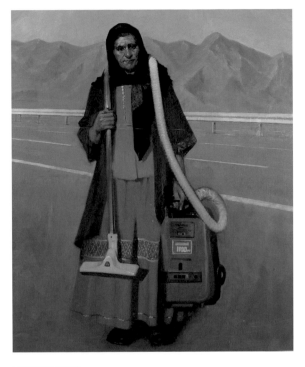

REPAIR DAY
arvish Fakhr
il on canvas
422 x 1168mm
6 x 46")

REPAIR DAY

This large-scale painting was inspired by a woman I saw hitch-hiking on the newly built autobahn between Tehran and Isfahan. It struck me as not only odd but also very revealing of contemporary Iran. She was probably a village woman – judging by her colourful traditional costume – who needed to get her vacuum fixed in town, which was at least two hundred miles south of where she lived.

The woman who helped me re-create the scene and posed for the painting is Nasrine Khanoom, who is a registered nurse. She would come over regularly either to bring us soup, model for me or check our heart rates. She gets paid very little at the hospital and was so thrilled that I was paying her for modelling that she bought her neighbours a live chicken for dinner.

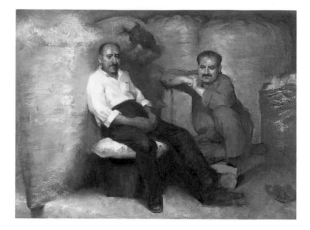

COTTON STUFFERS
Darvish Fakhr
Oil on canvas
560 x 762mm
(22 x 30")

COTTON STUFFERS

These two brothers sold cotton that is used to stuff cushions, blankets and mattresses. The business has been handed down by their great-grandfather who sold stuffing out of the same shop.

The Isfahan bazaar goes back at least five hundred years. 'Isfahan nesfe jahane' ('Isfahan is half of the world') is an expression that dates back to the sixteenth century when half the world travelled through the city as it was a mainstay and trading post on the Silk Route. There is even a camel hotel which still exists to this day. What interested me about this painting was how the brothers actually appeared to be part of the products they were selling, sitting comfortably in their padded interior, happily passing time with idle chitchat and hot tea.

Many of my sitters within the Iranian bazaar seemed like they were from a different century. Keeping my work from appearing anachronistic proved extremely challenging, especially as my previous work has often been described as depictions of modern-day life painted with somewhat traditional techniques. What was important to me was staying honest to what I saw and depicting the bazaar as it appears today. It remains remarkably resistant to Western influences.

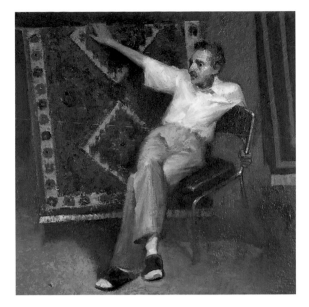

CARPET SELLER
Darvish Fakhr
oil on canvas
457 x 457mm
(18 x 18")

CARPET SELLER

This man is named Farhad and he sells Persian carpets in the Isfahan bazaar. The carpets are mostly made in the villages by groups of people (usually women) who sit at the loom and follow complex geometric patterns that are all worked out beforehand. When the carpet is finished it is brought to the bazaars by the men. Here they try to fetch the highest price, which varies depending on the complexity of the weave, the thread count, geometric accuracy and most importantly the general aesthetic.

I started this painting because of his pose. It felt not only very indigenous, but it also seemed to be a pose that he would be able to hold for some time. I set up and began the painting in the bazaar. To protect myself from the crowds of onlookers, I wore headphones (with no music) to give the impression that their questions and comments couldn't be heard, allowing me to concentrate. I then finished off the painting at home with the aid of photos and drawings.

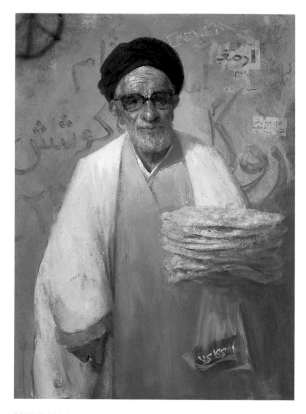

MULLAH ALI
Darvish Fakhr
Oil on canvas
760 x 560mm
(30 x 22")

MULLAH ALI

The first time I met Mullah Ali was when he came over
for lunch during Ramadan, which seemed odd as this is
a holiday when all Muslims are told to fast during day-
light hours. Mullah Ali came into his calling fifteen years
ago when his son died fighting in the Iran–Iraq war. At
eighty-three, he has just become a black belt in karate.

The wall behind is covered in graffiti, inspired by the
Persian tradition of painting that includes ornate scrip-
ture within the imagery – usually in the form of poetry.
The bread comes from a local bakery, where I went
every morning, and of course Coke is everywhere (the
name on the cans is even translated into Farsi).

ACKNOWLEDGEMENTS

My thanks go to all the artists who entered for the BP Portrait Award 2005, as well as those selected for the exhibition and to the four short-listed artists. I would like to acknowledge the hard work and clear thinking of an excellent set of judges: Maggi Hambling, Juliet Horsley, Brian Sewell and Des Violaris.

I should also like to offer special thanks to Philip Hensher for his essay and for adding another dimension to the project. I am also grateful to Caroline Brooke Johnson, Ruth Müller-Wirth and Anne Sørensen for their work on the catalogue, and to Beatrice Hosegood for co-ordinating the 2005 BP Portrait Award exhibition. Pim Baxter, Neil Evans, Annabel Dalziel, Ian Gardner, John Haywood, James Heard, Helen Heinkens-Lewis, Sarah Howgate, Liz Rideal, Howard Smith, Hazel Sutherland, Rosie Wilson and many other colleagues in the Gallery have contributed so helpfully and I am very grateful to them.

I should like to give great thanks to BP for their continuing support of the Portrait Award. BP is a strong partner for the exhibition and competition, and we are delighted to have the continuing support of Lord Browne and the company.

SANDY NAIRNE
Director, National Portrait Gallery

PICTURE CREDITS

INDEX

Figures in *italics* refer to illustrations.

Altoviti, Bindo 8–9, *9*, 10, 14
Anderson, Jackie *22*
Anderson, Jennifer *23*

Birdsall, Paul *24*
Burdett, Peter Perez *11*, 11–12
Busschers, Annemarie *25*

Calvino, Italo 14
Castronova, Davide *26*
Cheetham, Sean *27*
Clarke, Sylvie *28*
Cumins, Gregory *19*

Davies, Megan *29*

Eastland, Roy *30*
Ely, Joel *31*

Fakhr, Darvish 72, 73, *74–78*
Fragonard, Jean Honoré 8
Fraile-Ugalde, Eneko *32*

Hart Dyke, James *33*
Hogarth, William 12;
 The Graham Children 12
Hughes, Daniel *34*
Hugo, Helena *35*
Hutchinson, Sheldon *36*

*Inayat Khan, the Dying
 Courtier* 13, *13*

James Nielsen, Shaun *37*
Jahangir, Emperor 13
Joseph, Duncan *38*

Kelly, Brendan *39*
Kettlewell, Jack *40*

Lamont, Ian *41*

McCarthy, Maeve *42*
McInerney, Jay 14
McLoughlin, Cian *43*
Marsh, Dean *17*
Martin, David *44*
Middleton, Nicholas *45*

Milton, Graham *46*
Munday, Daniel *47*
Murphy-Woolford, John *48*

Okamura, Tim *49*
Oxborough, Paul *50*

Pankhurst, Andy *51*
Philipps, Nicky *52*

Ramsay, Allan:
 The Artist's Wife 10–11, 14
Raphael:
 Bindo Altoviti 8–9, *9*, 10, 14
Rembrandt van Rijn 8
Rennie, Alex *53*
Reynolds, Sir Joshua:
 *The Family of the Duke of
 Marlborough* 12
Robertson, Saul *18*
Rogers, Stephen Earl *54*
Rops, Félicien 8

*Sheikh Hosein Jami
 and his Attendant* 12–13
Sheiko, Konstantin *55*
Smith, Paul *56*
Steel, Charlotte *57*

Thompson, Bonnie *58*
Tift, Andrew *59*
Towler, Stefan *60*
Tremas, Thierry Louis *61*

Walker, Jason *62*
Walton, Conor *20*
Webb, David *63*
Wesley, Emma *64*
Williams, Antony *65*
Wilson, Hugo *66*
Wray, Daniel *67*
Wright, Joseph, of Derby:
 *Peter Perez Burdett and his
 First Wife Hannah 11*, 11–1
Wylie, Craig *68*

Yeo, Jonathan *69*
Young, Gavin *70*